· Jamie & Luke ·

Tooth fairy

· Ewa Lipniacka · Basia Bogdanowicz ·

Crocodile Books, USA

An imprint of Interlink Publishing Group, Inc.
NEW YORK

Anna had just lost a front tooth, and she was telling
Jamie and Luke all about the tooth fairy.

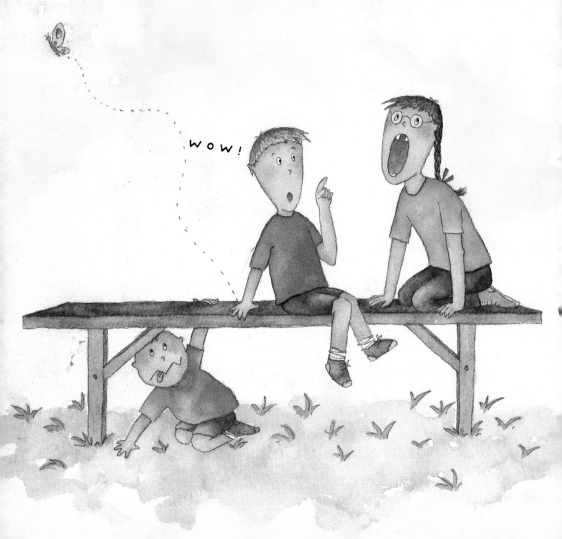

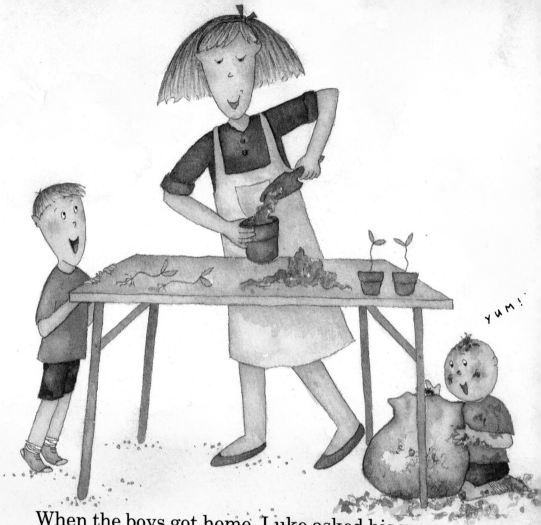

YUM!

When the boys got home, Luke asked his mom whether the tooth fairy really gave children money. "Oh, yes," said Mom, "but only in exchange for a tooth."

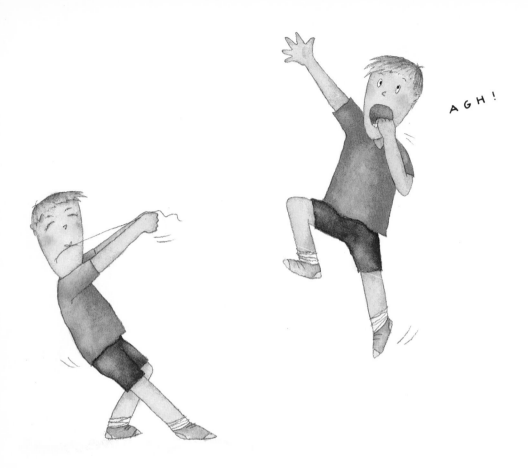

AGH!

So Luke spent all day trying to find a tooth for the
tooth fairy.
First he tried to pull out one of his own, but there
wasn't a loose tooth in his mouth.

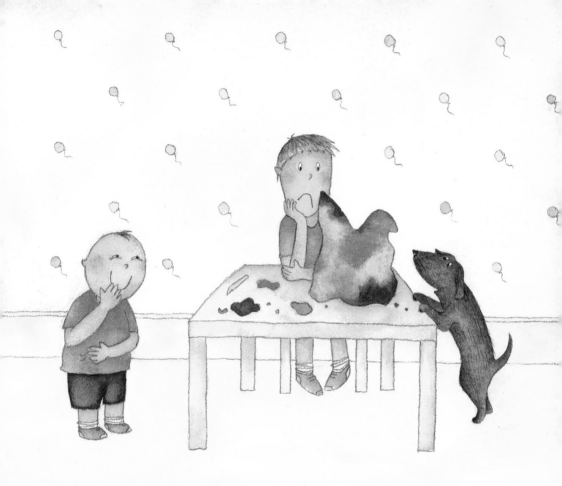

Then he tried to make a tooth out of play dough, but somehow he didn't think the tooth fairy would be fooled.

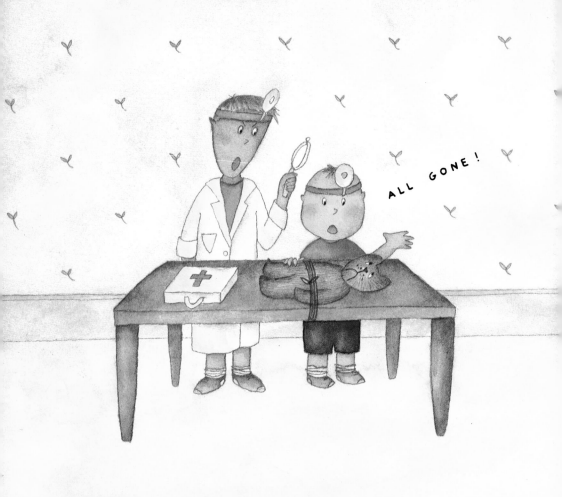

His teddy bear didn't seem to have any teeth at all.

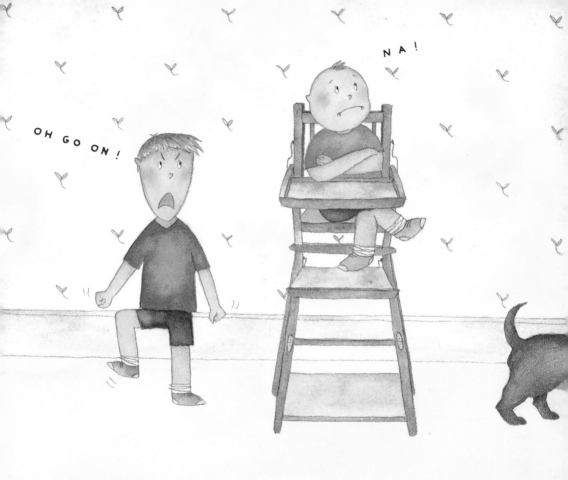

And Jamie wouldn't open his mouth with Luke
anywhere in sight.

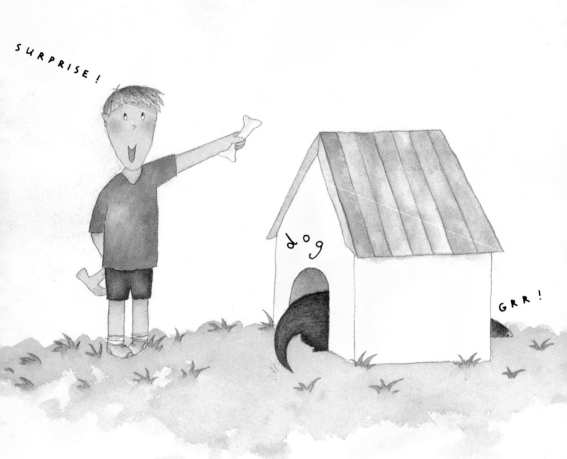

Neither would Oscar.

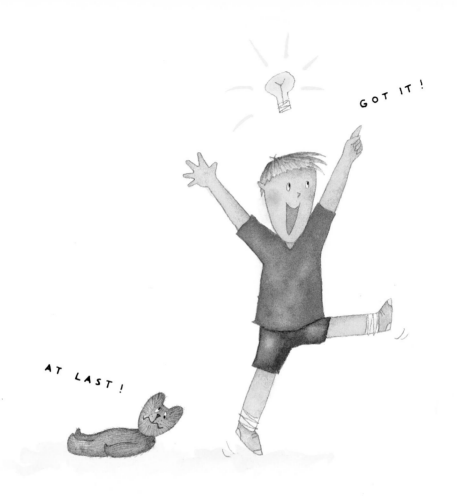

Then Luke had an idea.

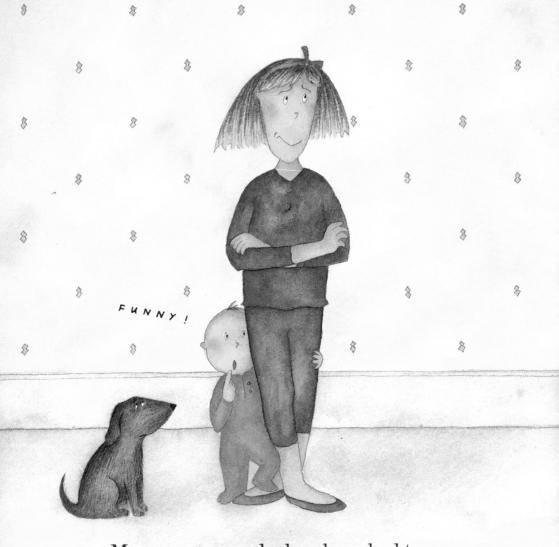

Mom was amazed when he asked to go
to bed early.

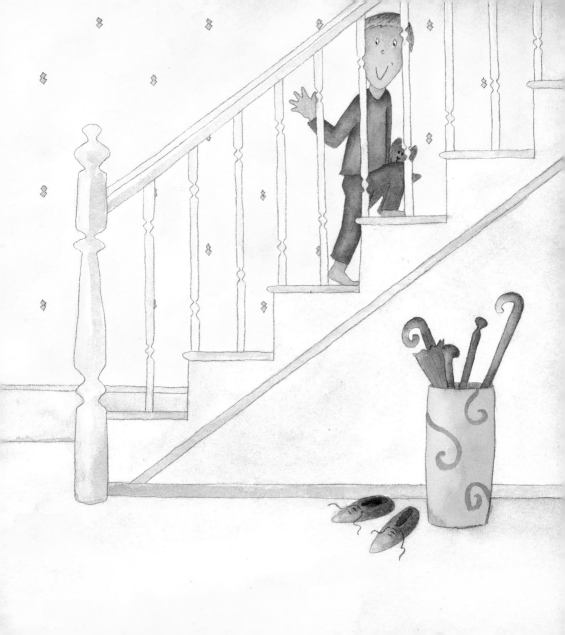

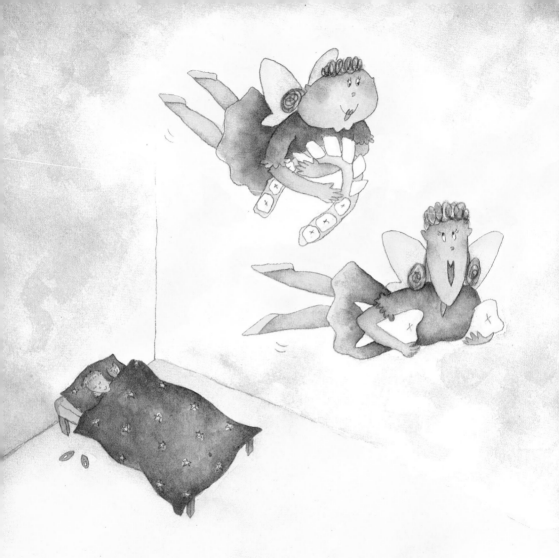

That night the tooth fairies were in for a big surprise . . .

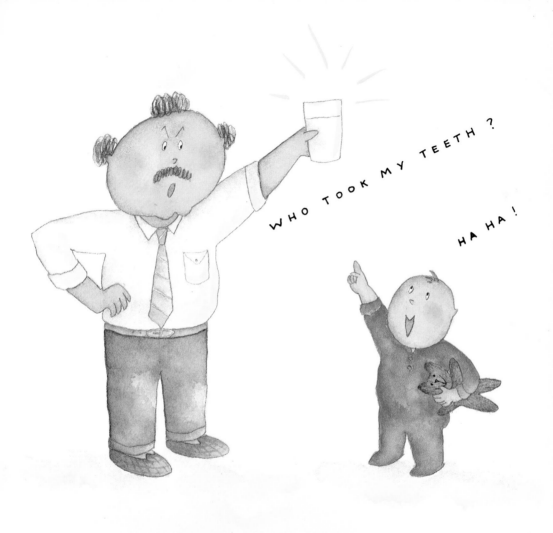

And so was Grandpa!